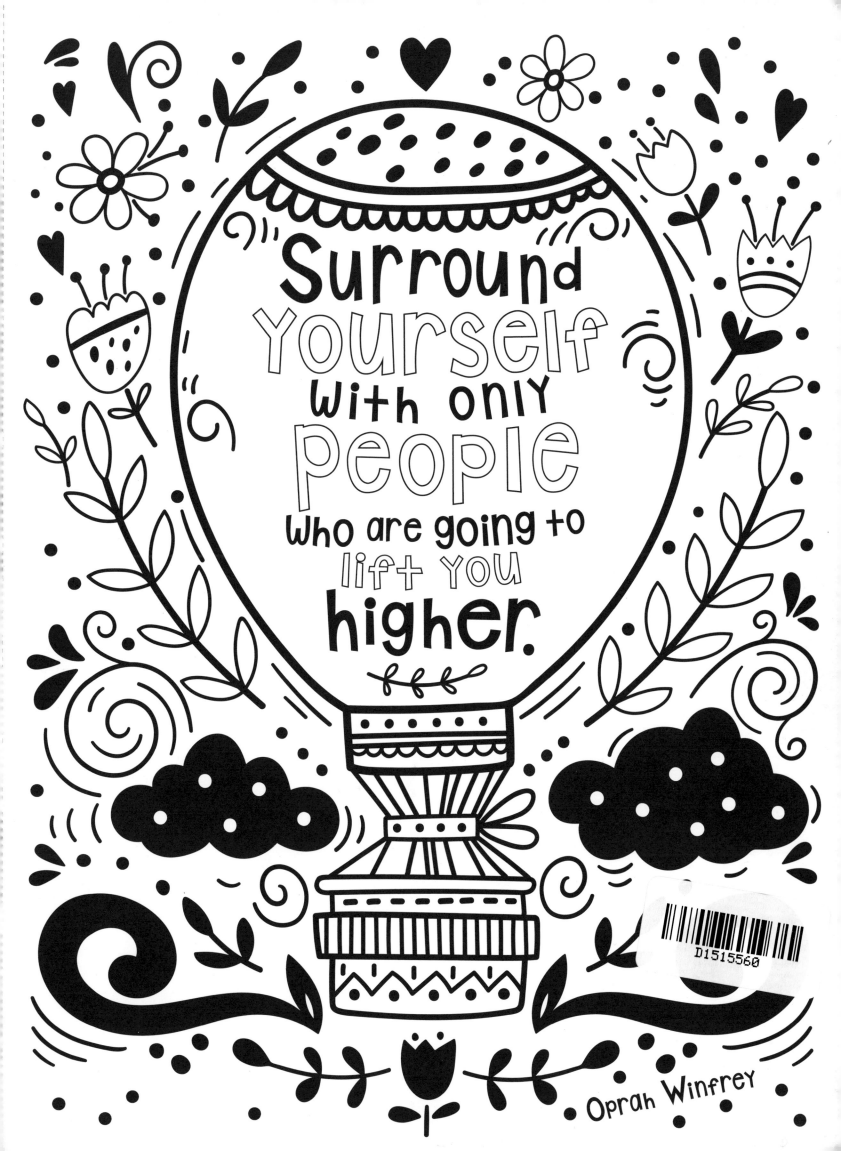

Surround yourself with only people who are going to lift you higher.

Oprah Winfrey

Oprah Winfrey

Born: Kosciusko, MS, 1954.

Oprah Winfrey is an African-American talk show host, television producer, entrepreneur and philanthropist. As of 2016, she is number two on *Forbes'* America's Richest Self-Made Women list, and her TV talk show consistently received the highest ratings of its kind in television history. Winfrey was born into poverty, followed by troubled early years. Being hired as co-anchor on a radio show while she was still in high school was a turning point. In 1986, her ad-lib, confessional-style program, *The Oprah Winfrey Show*, was picked up and syndicated. Winfrey's career and celebrity were made.

YOU can NEVER cross the OCEAN until you have the COURAGE to lose sight of the SHORE.

CHRISTOPHER COLUMBUS

Christopher Columbus

Born: Genoa, Italy, 1451.
Died: Valladolid, Spain, 1506.

Maritime explorer Christopher Columbus
discovered the "New World" – the
Americas – in 1492 on behalf of his
benefactor, King Ferdinand of Spain. This
"voyage into the unknown" – preceded by
Viking Leif Erikson – resulted in further
exploration, exploitation and settlement of
the Americas. Columbus' later voyages
of discovery were not successful, and
Columbus died rich but disappointed.

All our dreams can come true, if we have the courage to pursue them.

Walt Disney

Walt Disney

Born: Chicago, IL, 1901.
Died: Burbank, CA, 1966.

The Walt Disney name is synonymous
with cartoons, motion pictures, memorable
characters and Disneyland. In all, Disney
won a record twenty-two Academy Awards,
winning four Oscars in 1954 alone. He
started as an illustrator and experimented
with hand-drawn celluloid animation. Once
his first cartoons – *Newman's Laugh-O-
grams* – found distribution, Disney's studio
grew, and in 1928, Mickey Mouse was
born. The rest is history and … showbiz!

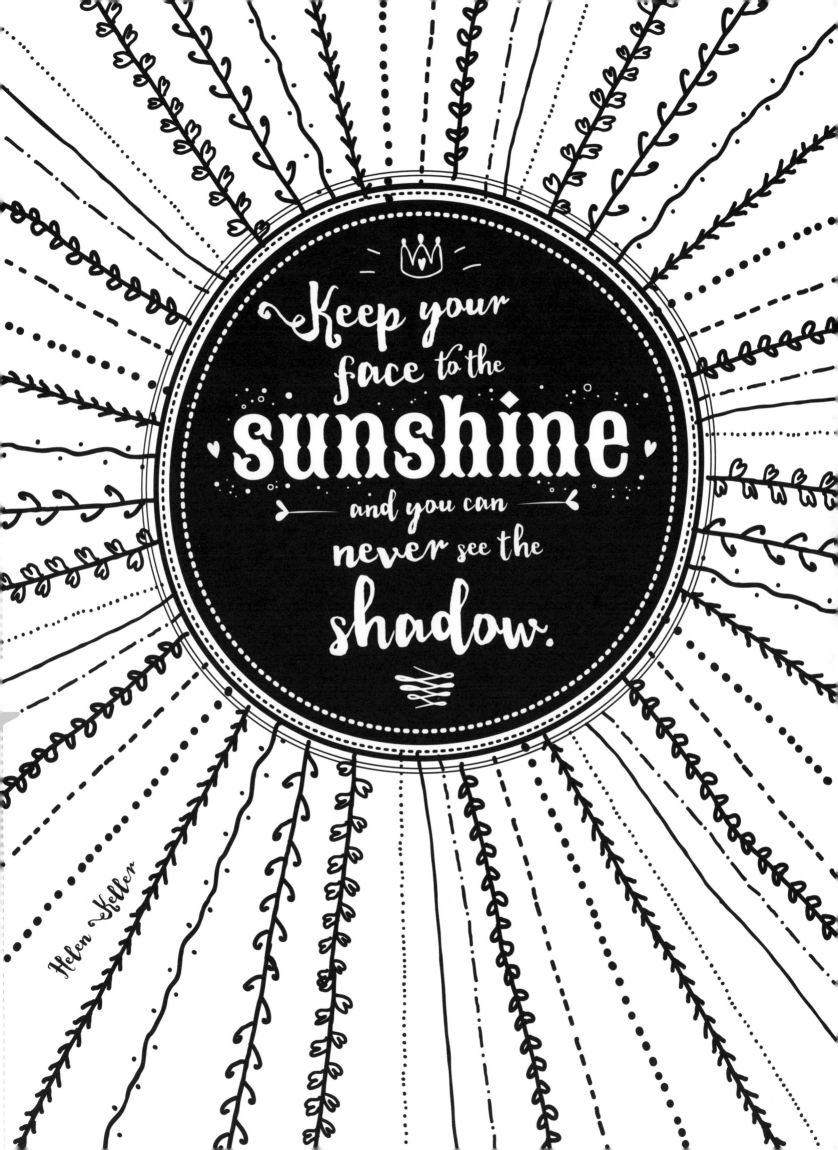

Helen Keller

Born: Tuscumbia, AL, 1880.

Died: Easton, CT, 1968.

Helen Keller became blind and deaf, possibly
due to meningitis or scarlet fever, when she
was just nineteen months old. By the time she
was seven, Helen had grown into an unruly,
clever child. But that all changed when Anne
Sullivan, a partially sighted teacher, came into
her life. In an effort to communicate with
Helen and teach her language, Anne wrote
manually, letter by letter, into Helen's palm
and linked the words to objects or sensations.
In 1904, Helen became the first deaf-blind
person to earn a college degree, and went on
to champion workers' rights, women's
suffrage, civil liberties, pacifism and, of
course, deaf-blind services.

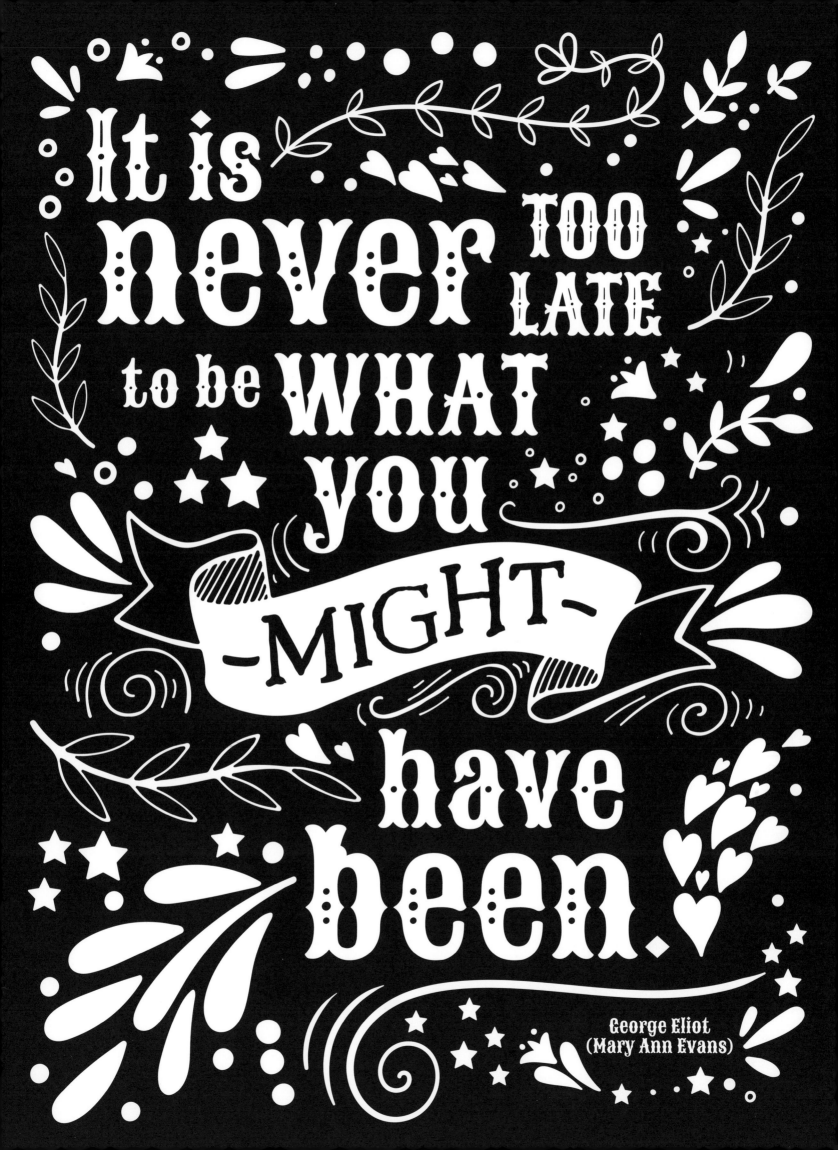

It is never too late to be WHAT you -MIGHT- have been.

George Eliot
(Mary Ann Evans)

George Eliot

Born: Chilvers Coton, England, 1819.
Died: London, England, 1880.

George Eliot was not Mary Ann Evans'
only other name. She was also known as
Marian Cross and Marian Evans. But she
adopted her masculine pen name so that
her novels, including *Adam Bede*, *The Mill
on the Floss*, *Silas Marner*, *Middlemarch*
and *Daniel Deronda*, would be taken
seriously in an era that believed women
only wrote romance novels. Eliot's novels,
especially *Middlemarch*, are noted for their
realism and psychological insights.

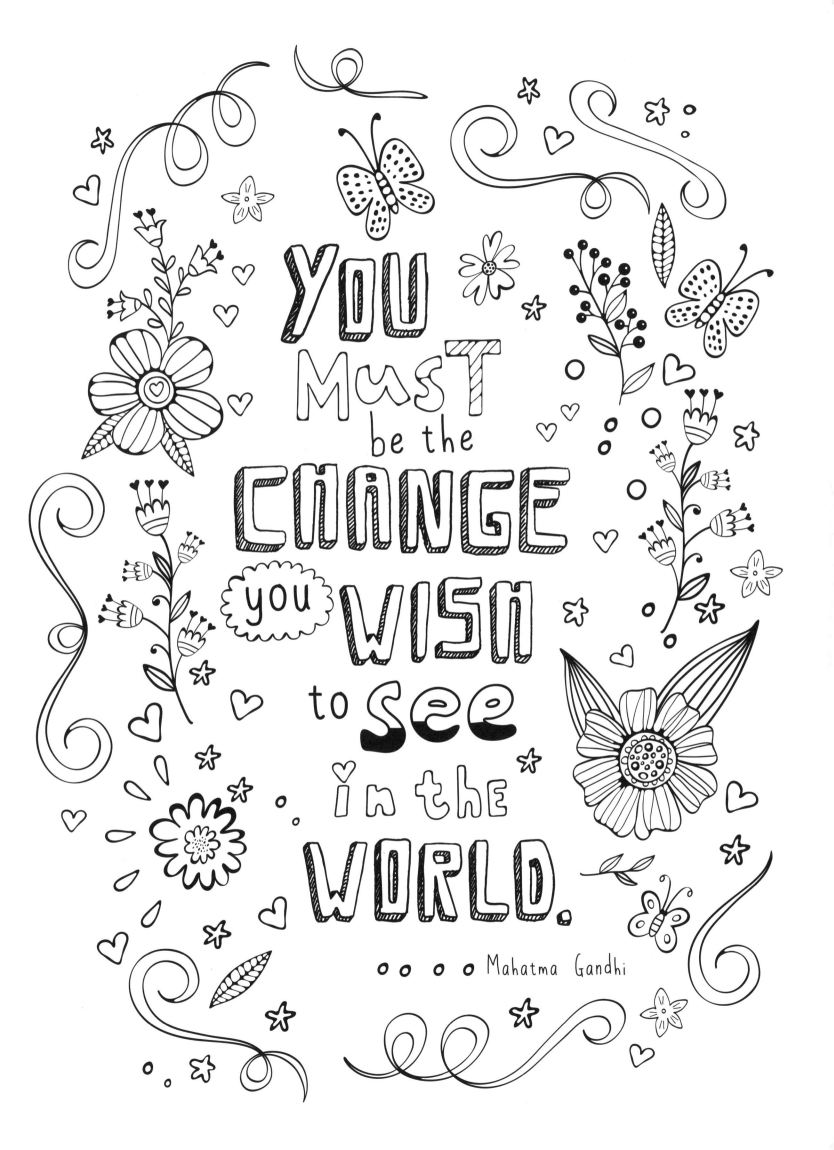

Mahatma Gandhi

Born: Porbandar, India, 1869.
Died: New Delhi, India, 1948.

Mahatma Gandhi is revered around the
world for his teaching and practice of
nonviolent protest, or *Satyagraha*, to
provoke social and political progress.
Nonviolence and mutual tolerance are
core elements of the religions Vaishnavism
and Jainism, in which Gandhi was raised.
But it was a trip to South Africa and his
experience of racial discrimination there that
ignited Gandhi's social conscience and his
lifelong mission to redress injustice.

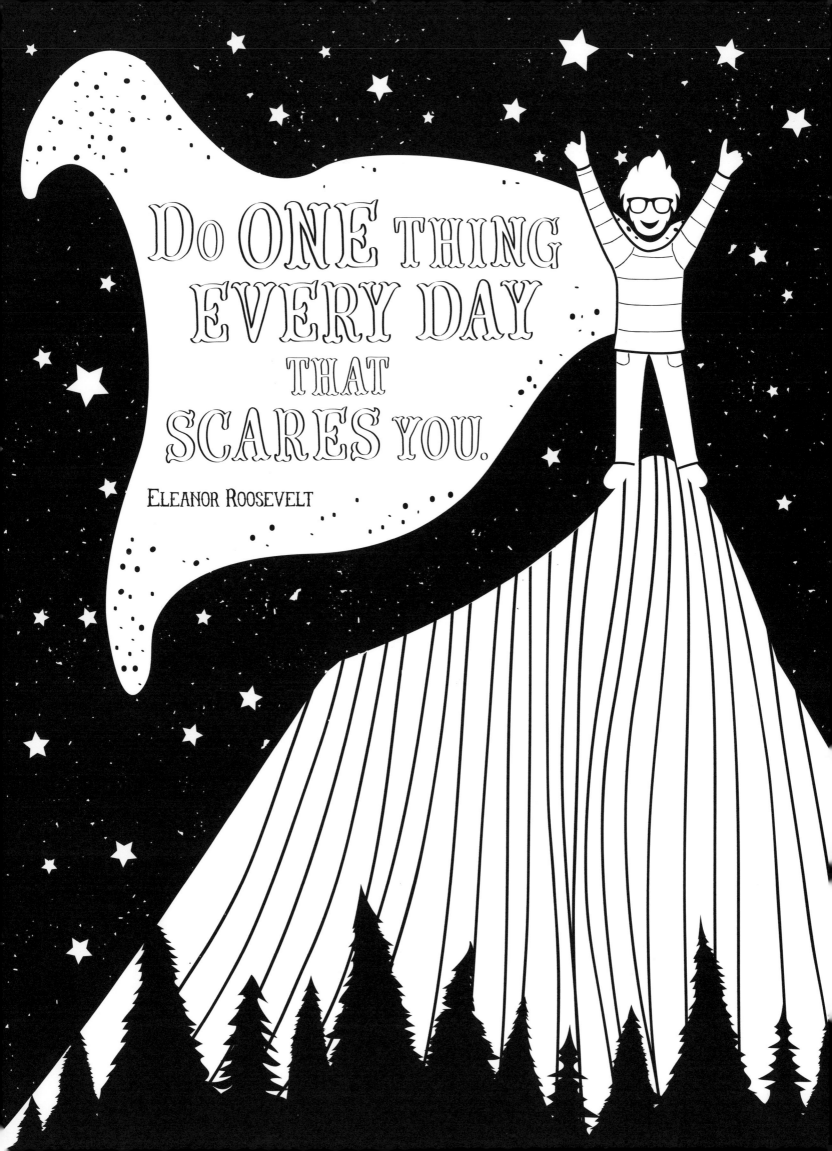

Eleanor Roosevelt

Born: New York City, NY, 1884.
Died: New York City, NY, 1962.

Before her marriage to President-to-be
Franklin D. Roosevelt, Eleanor Roosevelt
(Roosevelt was also her maiden name –
Franklin was a distant cousin) became
active in social reform movements,
especially those relating to fair labor
practices and safe housing. One of the
world's most respected women, her social
conscience and strong interest in politics,
women's issues and human rights never
faltered, and she championed these
causes when she became First Lady
of the United States.

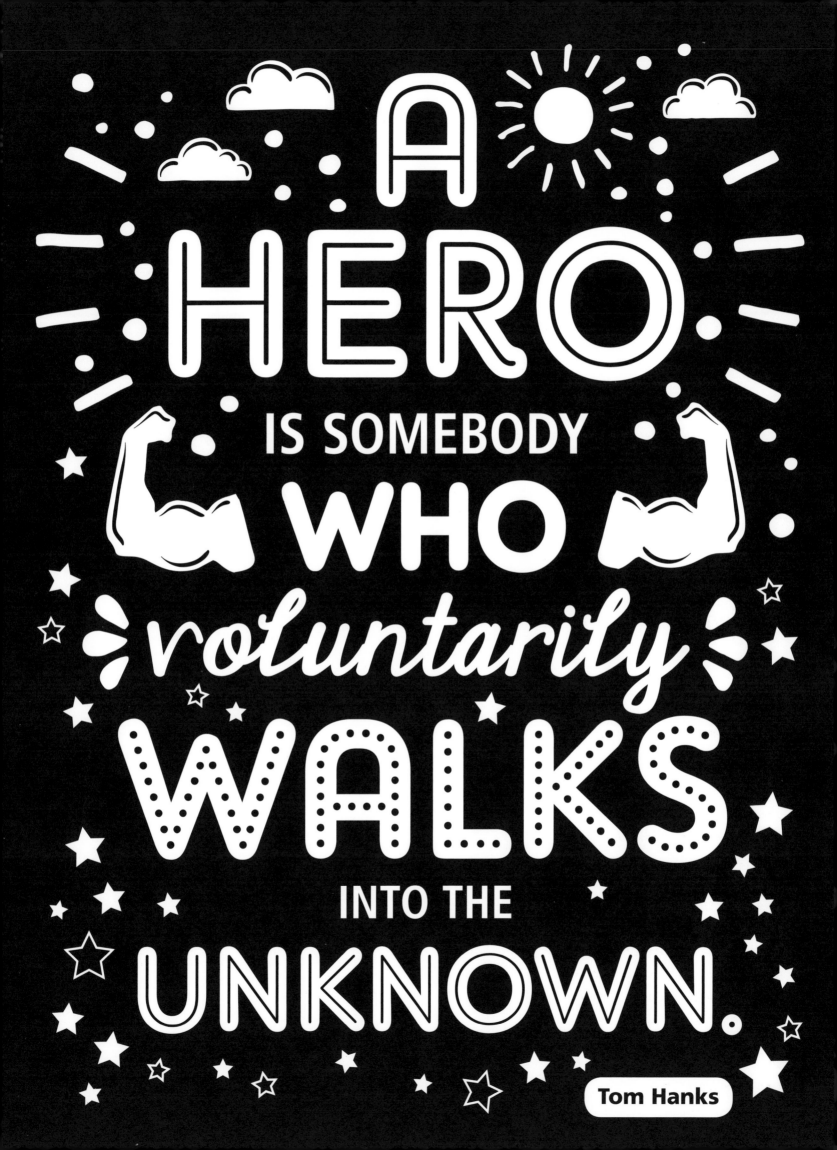

A HERO IS SOMEBODY WHO voluntarily WALKS INTO THE UNKNOWN.

Tom Hanks

Tom Hanks

Born: Concord, CA, 1956.

Tom Hanks started performing when he was in high school, sometimes in school plays, but mostly to entertain his friends. His first break came in 1978 when he won a critics' award for his performance of Proteus in *The Two Gentlemen of Verona*. His second break came with the film *Big*. Hanks' many film credits include *Philadelphia*, *Forrest Gump*, *Apollo 13*, *Saving Private Ryan* and *Cast Away*. Among younger audiences, Hanks is known as the voice of Woody in the *Toy Story* film series. Not only is he acknowledged as a great actor, Hanks has the reputation of being one of the nicest guys in show business.

It does
NOT
MATTER
how
SLOWLY
you **GO**,
so **LONG** as
YOU
DO NOT
STOP.

CONFUCIUS

Confucius

Born: Qufu, China, 551 BCE.
Died: Qufu, China, 479 BCE.

Born Kong Qiu, he became better known as
Confucius, the philosopher and teacher of
ethical models of family and society
interaction. His ideas on rén ("loving others")
and integrity are contained in *The Analects of
Confucius*, or *Lunyu*. A philosopher, teacher
and political figure, Confucius is particularly
known for his writings espousing modesty,
honesty and sincerity, penned as concise
and easily recalled aphorisms. At the time
of his death, Confucius is thought to have
had 3,000 disciples; today, followers are
estimated to be around 350 million.

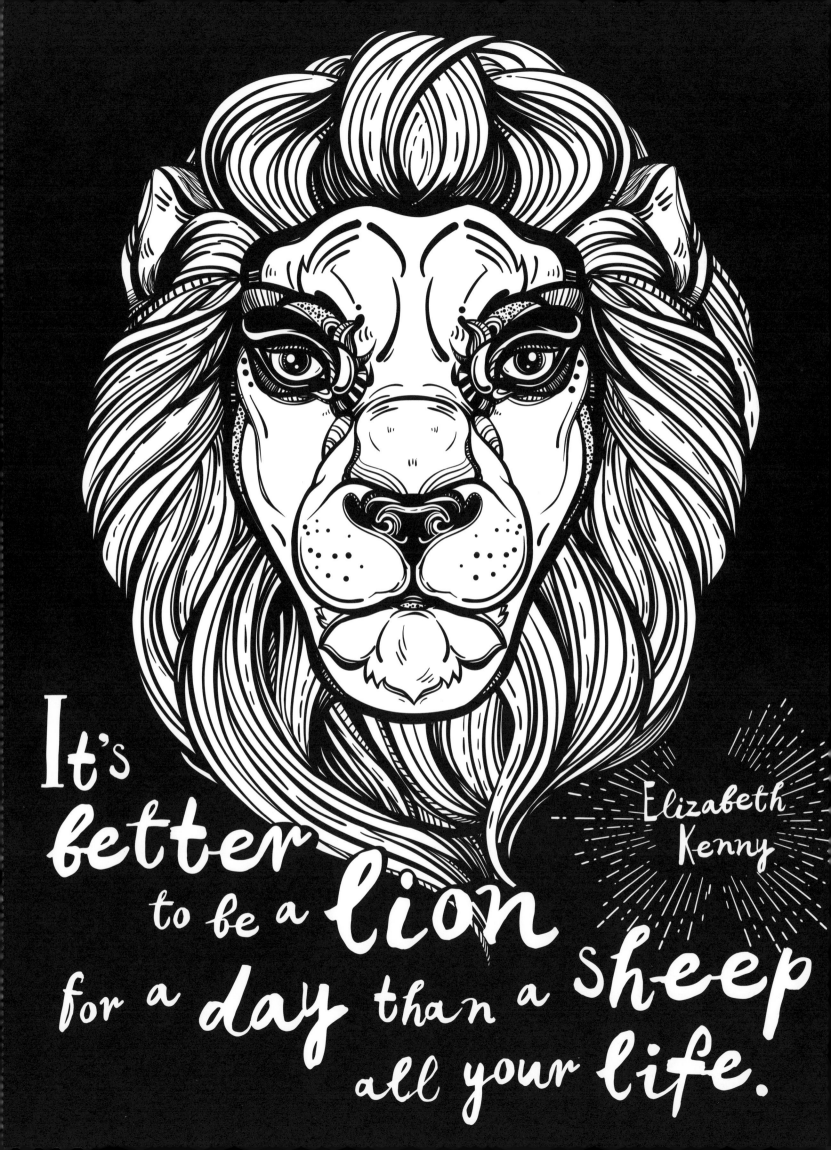

It's better to be a lion for a day than a sheep all your life.

Elizabeth Kenny

Elizabeth Kenny

Born: Warialda, Australia, 1880.
Died: Toowoomba, Australia, 1952.

The "Kenny Method," an alternative approach
to the treatment of polio, is named for Australian
nurse Elizabeth Kenny. During World War I,
she nursed wounded soldiers on troopships,
and later patented the Sylvia Stretcher for
ambulances. Kenny was a passionate nurse,
an innovator and a spirited individual. In 1946,
her life became a film, *Sister Kenny*, starring
Rosalind Russell as Kenny.

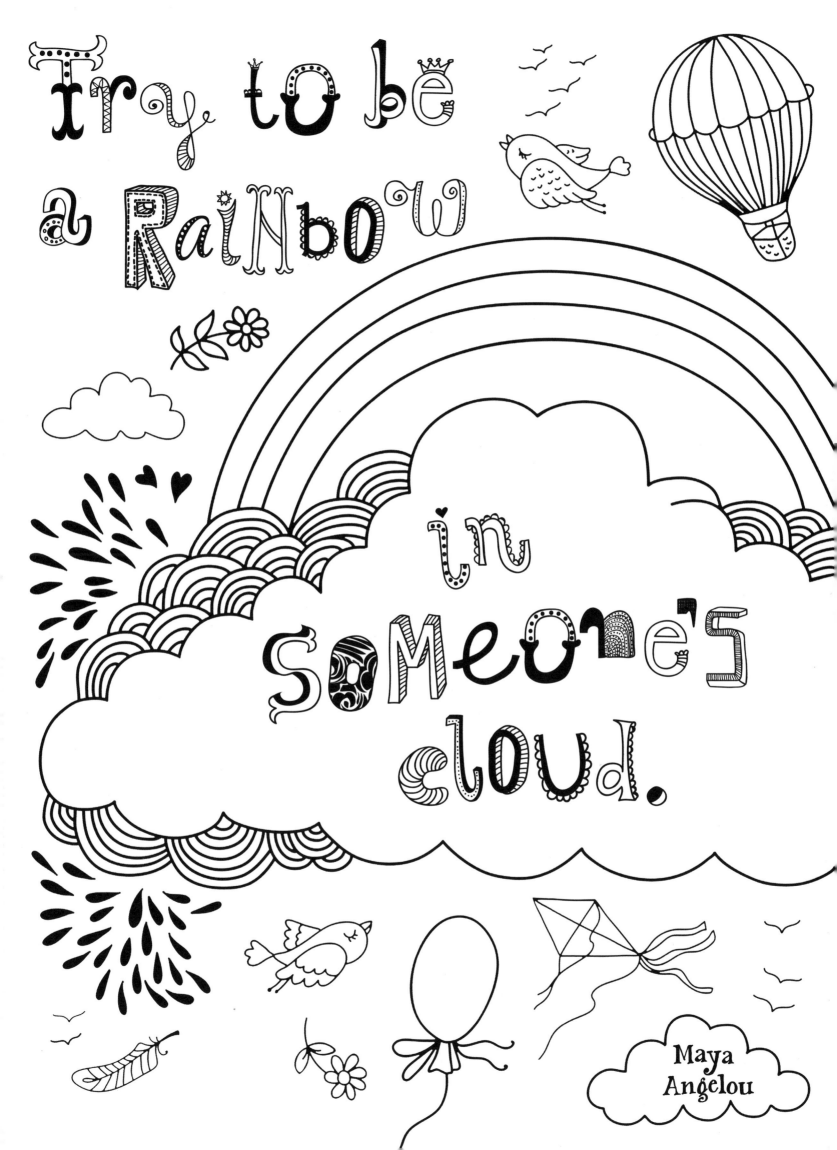

Try to be a Rainbow in Someone's cloud.

Maya Angelou

Maya Angelou

Born: St. Louis, MO, 1928.
Died: Winston-Salem, NC, 2014.

Angelou was a poet, author, playwright, dancer, producer, performer, singer and civil rights activist whose memoir, *I Know Why the Caged Bird Sings*, is a coming-of-age story and an honest look at racial prejudice in America. It was the first nonfiction best seller by an African-American woman. Angelou recited her specially written poem, "On the Pulse of Morning," at President Clinton's inauguration in 1993. She leaves a remarkable legacy.

Oscar Wilde

Born: Dublin, Republic of Ireland, 1854.
Died: Paris, France, 1900.

Oscar Wilde, Irish author, poet and
playwright, is best known for his novel
The Picture of Dorian Gray and his play
The Importance of Being Earnest. An
exemplary student at Trinity College, Dublin,
and at Oxford University, Wilde had moderate
success as a poet, which gave him the
opportunity to do a lecture tour in America,
and edit *The Lady's World* magazine. This
was followed by popular and critical acclaim
for his books. Wilde though, had less success
in court, and in 1895 was sentenced to two
years with hard labor, ingloriously celebrated
in his poem "The Ballad of Reading Gaol."

Forget not that the earth delights to feel your bare feet and the winds long to play with your hair.

Kahlil Gibran

Kahlil Gibran

Born: Bsharri, Lebanon, 1883.
Died: New York City, NY, 1931.

This Lebanese-American poet, artist and
writer – his family immigrated to the US
when he was young – is best known for
his book *The Prophet*. Published in 1923,
it gained huge popularity in the 1960s
among the New Age and counterculture
movements. Consisting of twenty-six poetic
essays, *The Prophet* deals with spiritual
love and mysticism drawn from many
religions. John Lennon slightly amended
a line from Gibran's "Sand and Foam"
poem in The Beatles' 1968 song "Julia."

Our **LIVES*** **BEGIN** to **END** the day we become **SILENT** about things **THAT MATTER**.

Dr. Martin Luther King Jr.

Dr. Martin Luther King Jr.

Born: Atlanta, GA, 1929.
Died: Memphis, TN, 1968.

A third-generation Baptist minister, Dr. King had
always worked for civil rights and in 1955, he led
the first-ever, large-scale, nonviolent civil rights
demonstration in the US. This involved a 382-day
boycott of the buses in response to segregation.
His continuing work for civil rights earned him
the Nobel Peace Prize in 1964. At the age of
thirty-nine, Dr. Martin Luther King Jr. was
assassinated as he stood outside his hotel room
in Memphis, TN, on April 4, the night before he
was to lead a march of striking garbage workers.

Mother Teresa of Kolkata

Born: Skopje, Macedonia (FYROM), 1910.

Died: Kolkata, India, 1997.

Mother Teresa never thought of becoming
a nun until she was eighteen, when she joined
the Sisters of Loreto, a Roman Catholic
missionary and teaching order. In 1931, she
made her vows and began God's service as a
teacher in what was then called Calcutta, but
found her true calling working in the city's
slums. She convinced the Church to release
her from her vows and allow her to start a new
community. From 1948 to the end of her life,
Mother Teresa worked among the poorest of the
poor, and her Missionaries of Charity continues.
She was canonized by the Church in 2016.

Dalai Lama XIV

Born: Takster, Tibet, 1935.

The 14th Dalai Lama is the spiritual leader
of Tibet. He describes himself as "a simple
Buddhist monk." Chosen at the age of two
to be the reincarnation of the previous
Dalai Lama, he began his monastic
education at age six, assuming his
destined role as temporal ruler of Tibet
at age fifteen. His Holiness is recognized
and revered throughout the world as a
man of peace, and in 1989, he was
awarded the Nobel Prize for peace.

A champion is afraid of losing. Everyone else is afraid of winning.

Billie Jean King

Billie Jean King

Born: Long Beach, CA, 1943.

King's reputation extends well beyond the tennis courts where she won thirty-nine Grand Slams, including twenty Wimbledon titles. She is known as a formidable champion for social justice, gender equality and LGBTQ rights. In 1973, in her fight for gender equality, she challenged Bobby Riggs, a tennis champ and outspoken chauvinist, to a "Battle of the Sexes" on the tennis court. (King won the match in straight sets.) King was the first female athlete to be awarded the Presidential Medal of Freedom (2009) and in 2008 was appointed Global Mentor for Gender Equality by the United Nations Educational, Scientific and Cultural Organization (UNESCO).

Light tomorrow with today.

Elizabeth Barrett Browning

Elizabeth Barrett Browning

Born: Durham, England, 1806.
Died: Florence, Italy, 1861.

Browning always knew she would be a writer. She wrote her first verses at the age of four, for which she received 10 shillings and a note from her father that was addressed to: "the Poet Laureate of Hope End." Browning's critical success often eclipsed that of her husband, the poet Robert Browning. She was admired during her lifetime not only for her poetry, but for the acknowledgement in her poems of social injustices, such as the slave trade, child labor and the societal restrictions imposed on women. (Her epic novel in blank verse, *Aurora Leigh*, has attracted the praise of feminists.)

THINKING
IS **MORE** INTERESTING THAN **KNOWING,** BUT **LESS** INTERESTING THAN **LOOKING.**

{ JOHANN WOLFGANG VON GOETHE }

Johann Wolfgang von Goethe

Born: Frankfurt, Germany, 1749.
Died: Weimar, Germany, 1832.

Highly intellectual, even as a boy, Goethe studied languages, painting, music, law, natural sciences, drawing and printing, but his passion was literature. Goethe started his epic drama, *Faust*, when he was twenty-three but only completed it after almost sixty years. In later centuries, luminaries like Mozart, Beethoven, Brahms and Wagner set many of Goethe's poems to music. Goethe's influence extends to this day.

The question isn't who's going to LET ME; it's who is going to STOP ME.

Ayn Rand

Ayn Rand

Born: St. Petersburg, Russia, 1905.
Died: New York City, NY, 1982.

Russian-born novelist, playwright and philosopher
Ayn Rand is best known for her novels *The
Fountainhead* (1943) and *Atlas Shrugged* (1957).
The Fountainhead, the story of an architect who will
not compromise his vision, was made into a film
starring Gary Cooper (1949). In *Atlas Shrugged*,
Rand expounds on her philosophy of objectivism –
a philosophy which places high value on reason and
individual rights – in a storyline where overregulation
forces leading industrialists to abandon their money
and enterprise. Rand has been described as
purposeful, independent, rational, and
uncompromising, much like her fictional characters.
The *New York Times* reviewer of *The Fountainhead*
called her a "writer of great power."

I AVOID LOOKING FORWARD OR BACKWARD, AND TRY TO KEEP LOOKING UPWARD.

CHARLOTTE BRONTË

Charlotte Brontë

Born: Thornton, England, 1816.

Died: Haworth, England, 1855.

The third of six children of the Reverend and
Mrs. Brontë, Charlotte started writing at age
ten when she began to create the imaginary
Kingdom of Angria, based on the games she
and her siblings played with toy soldiers.
After working as a teacher and a governess,
Charlotte and her sisters opened their own
school, but it was not a success. This might
have been a blessing, as otherwise
Charlotte may never have written *Jane Eyre*,
her most acclaimed novel.

BIG doesn't *necessarily mean* **better.**
SUNFLOWERS *aren't better than* **VIOLETS.**

EDNA FERBER

Edna Ferber

Born: Kalamazoo, MI, 1885.
Died: New York City, NY 1968.

Edna Ferber's books and plays focus on the lives of average Americans. They often feature women with a drive to succeed pitched against conservative Midwestern values. The first of these distinctive female characters appeared in *Emma McChesney & Co.* in 1915. Ferber wrote about Selina Peake in *So Big* in 1924, which won the Pulitzer Prize. Films and musicals based on her books include *Giant* (1956), which starred Elizabeth Taylor, Rock Hudson and James Dean; and *Show Boat*, an acclaimed and often revived musical play from Oscar Hammerstein II and Jerome Kern, first produced in 1927.

Nelson Mandela

Born: Mvezo, South Africa, 1918.
Died: Johannesburg, South Africa, 2013.

As a boy, Mandala heard inspiring stories of his ancestors' bravery during the wars of resistance and their actions in the name of freedom. Mandela joined the African National Congress in 1944, and by 1956 was on trial for the first – but not the last – time. In 1963, his actions against the apartheid state, especially inciting workers to strike, had him on trial for sabotage. For this, he and seven others were sentenced to life imprisonment. Released in 1990, he negotiated an end to white minority rule with South Africa's president, F. W. de Klerk. In 1994, Mandela became the country's first democratically elected president. He was, and remains, an inspiration to the world.

Deepak Chopra

Born: New Delhi, India, 1947.

As the world's most prominent advocate and
practitioner of alternative medicine and the
New Age movement, Chopra is not without
his detractors in the conventional medical and
scientific establishments. Chopra is a licensed
physician, but after meeting Maharishi Mahesh
Yogi in 1985, he went on to cofound the
Chopra Center for Wellbeing in 1996. His
practice combines traditional Hindu medicine,
mainstream medicine, mindfulness, primacy
of the conscious, yoga and meditation to
treat disease and extend lifespan.